T0096335

MORE
CLASSIC ART MEMES

First published by Studio Press in 2020,
an imprint of Bonnier Books UK,
4th Floor, Victoria House, Bloomsbury Square, London, WC1B 4DA
Owned by Bonnier Books,
Sveavägen 56, Stockholm, Sweden

www.bonnierbooks.co.uk

With text by Ellie Ross
Edited by Sophie Blackman
Designed by Rob Ward

3 5 7 9 10 8 6 4 2

MIX
Paper from
responsible sources
FSC® C104723

A CIP catalogue for this book is available from the British Library

Printed in China

MORE
CLASSIC ART MEMES
Art History Rewritten

*When you use Dress-Down Fridays
to showcase your personality.*

When you get your quiz sheet back and the other team have only given you half a point for a correct answer.

When her Tinder™ *bio said,*
'cute but psycho'.

*When you order your
first turmeric latte.*

When he said you couldn't get a cat.

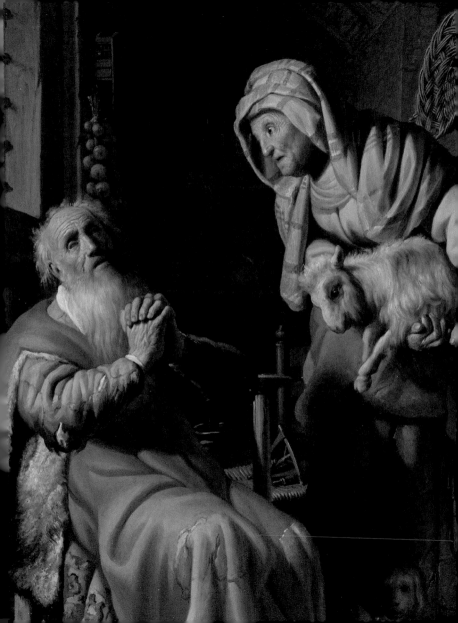

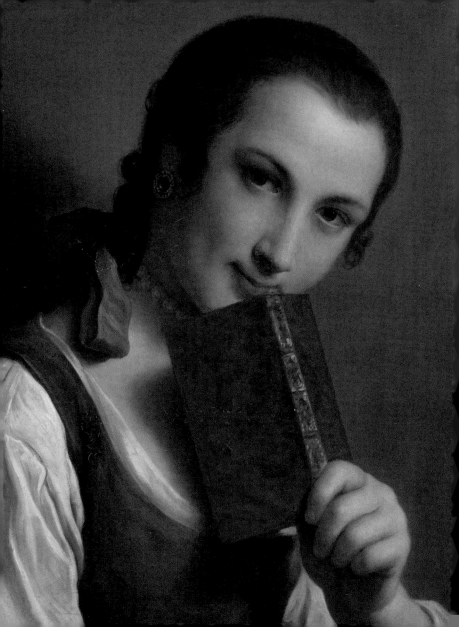

When all you've written so far is 'Dear Diary' but you know it's going to be good.

When your girlfriend goes all out for Halloween.

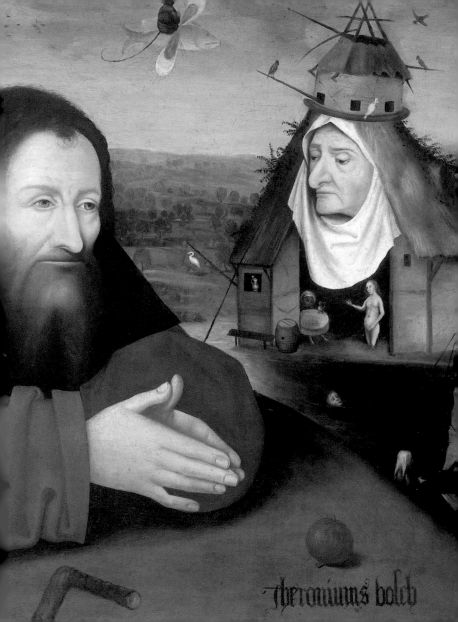

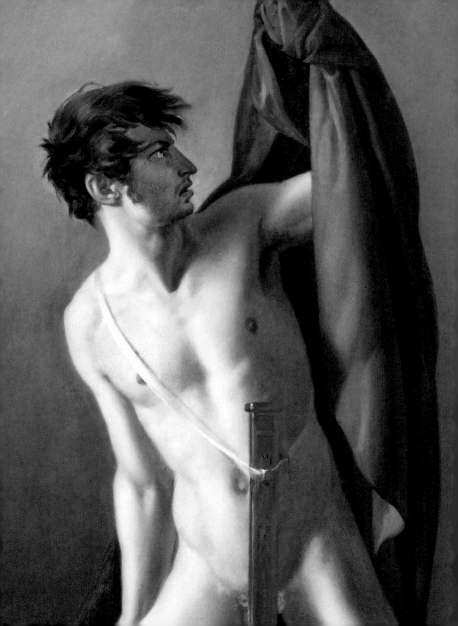

When your mum says your outfit is too skimpy and makes you put a coat on.

When you wear sandals made of organic yoghurt and brew your own kale-flavoured beer.

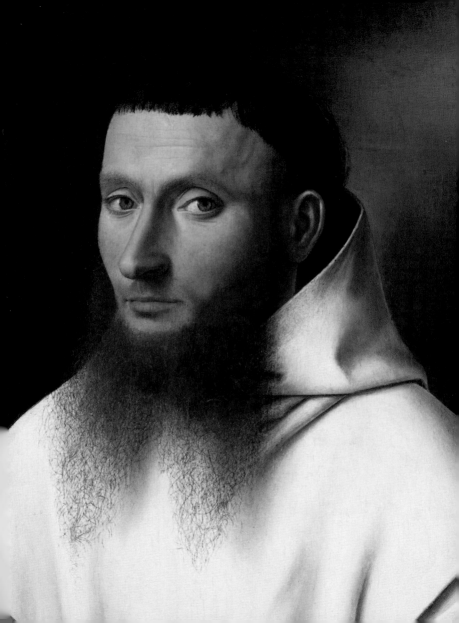

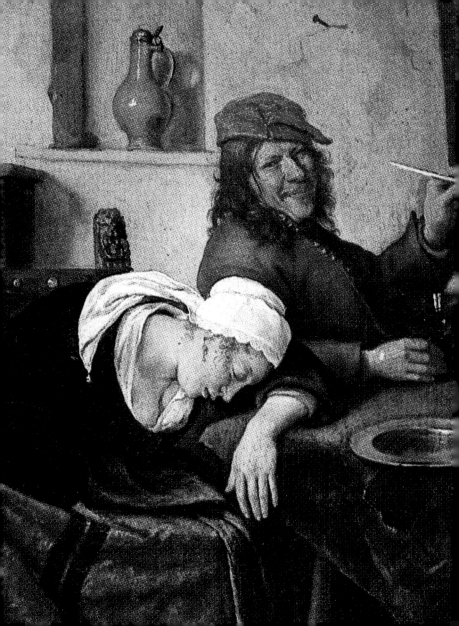

*When your dad has made
the same joke three times.*

When your neighbour says their dog is just being friendly.

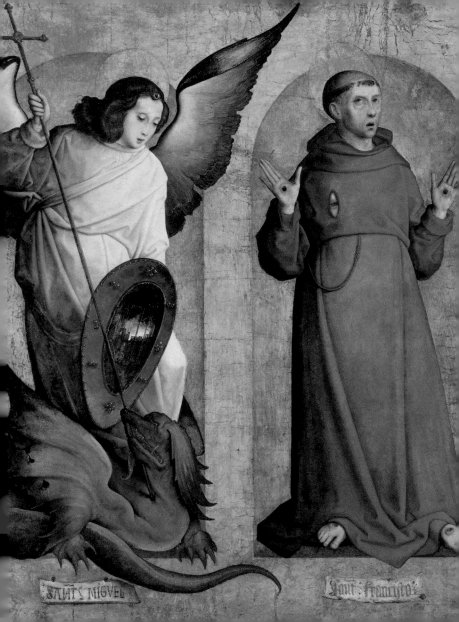

SANT MIGVEL Sant Francisco

When you're the first in your group to pass your driving test.

When your drunk friend asks, 'what's the point?' and you realise you really don't know.

When you sit back and enjoy the drama.

When your family buy you an iPad for Christmas and you don't even know how to turn the thing on.

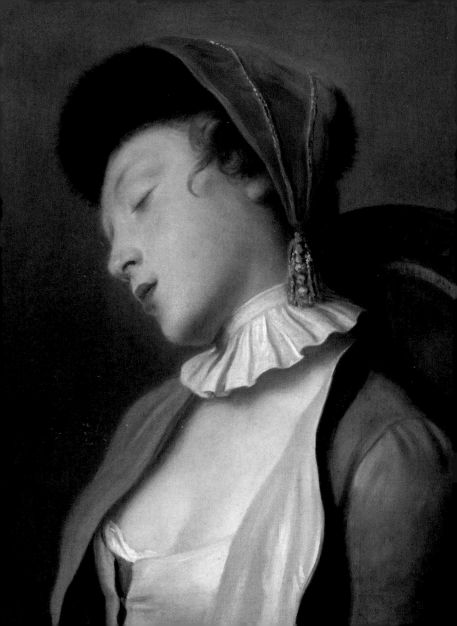

When your vegan friend is talking about how cheese substitutes are 'just as good as the real thing'.

*When your crush says
'have a great day, Matt!'
and your name is Mark.*

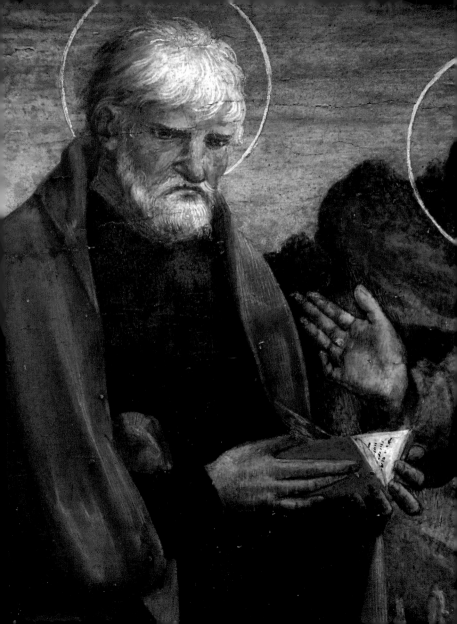

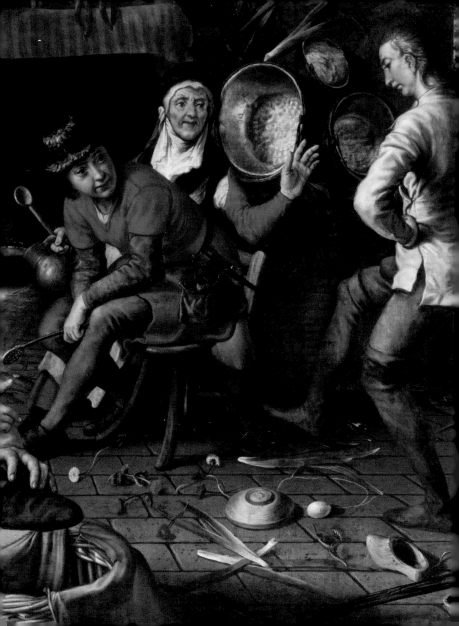

When your mum makes you walk around the shoe shop to see how they feel.

When someone steals your joke and gets a massive laugh.

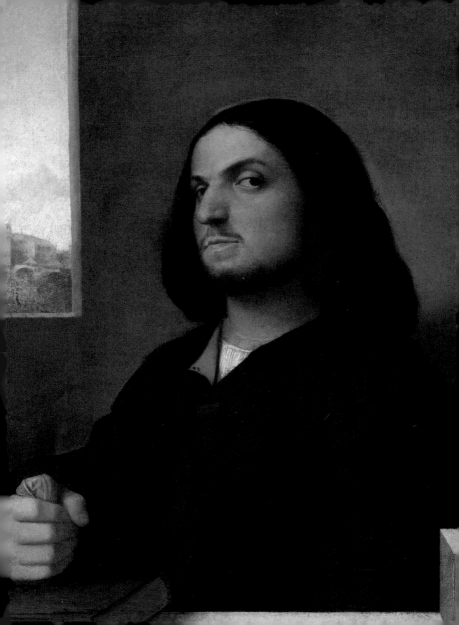

When your pet looks more like you than you do.

*When a slow song comes
on at the school disco.*

*When your dad sees you leave
a room without turning
off the light.*

When you can hear your neighbours having an argument in the back garden.

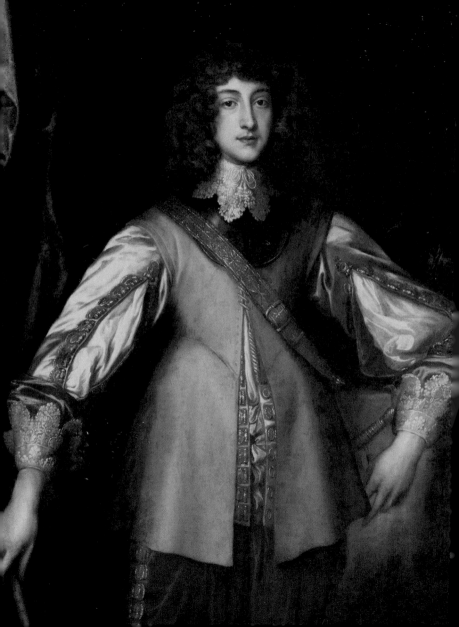

When your little brother Timmy says 'it's Timothy now'.

When someone sits next to you on the bus despite the twenty-five other empty seats.

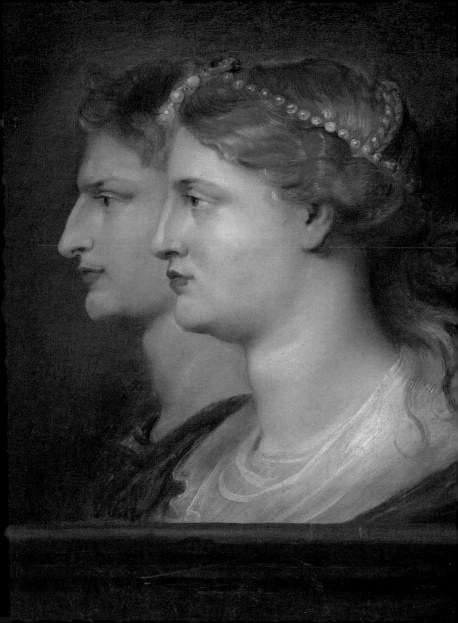

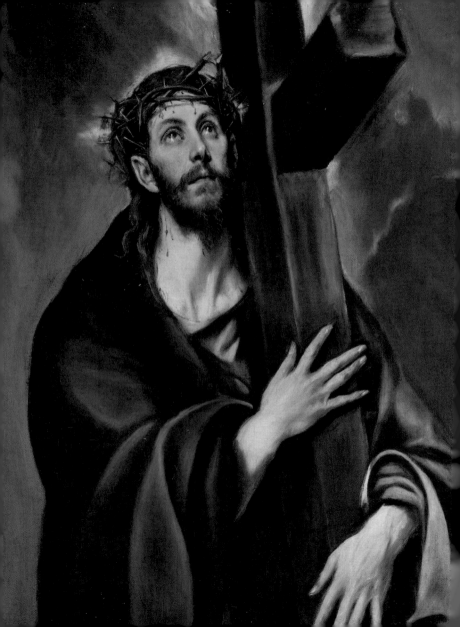

When your dad asks you to hold the ladder then starts chatting to a neighbour.

When one of you isn't tall enough to ride the rollercoaster.

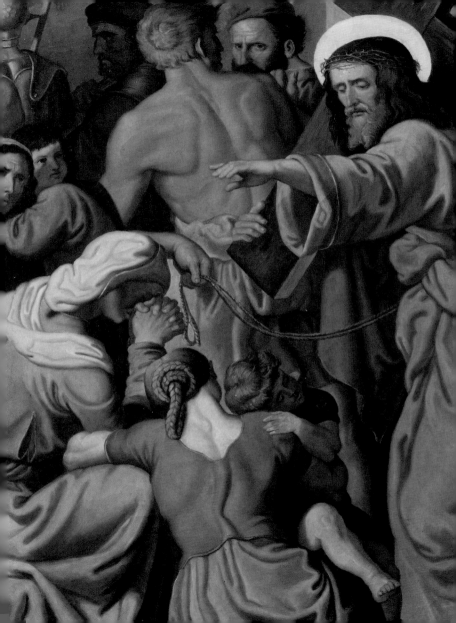

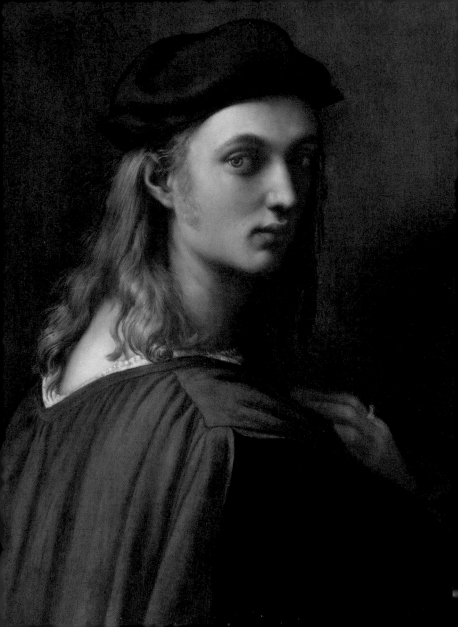

When you run out of dry shampoo and have to very quickly become a hat person.

When you finally swap your Lynx Africa™ for something that costs more than a fiver.

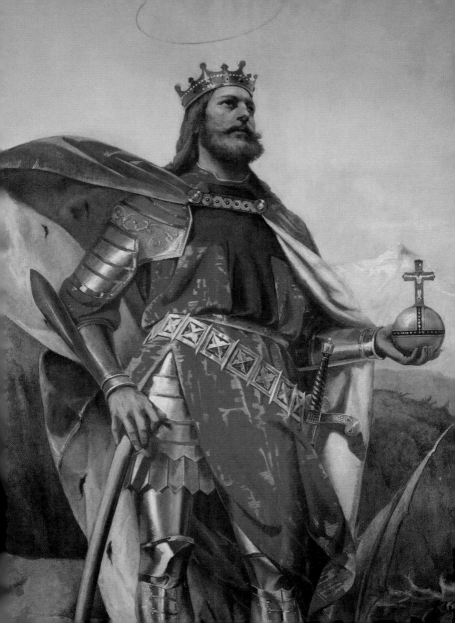

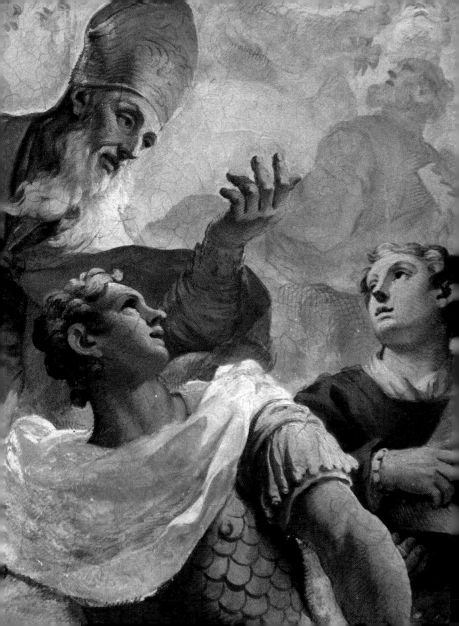

When you're having a private conversation and a stranger says 'I couldn't help overhearing…'.

*When you blame your
fart on the dog.*

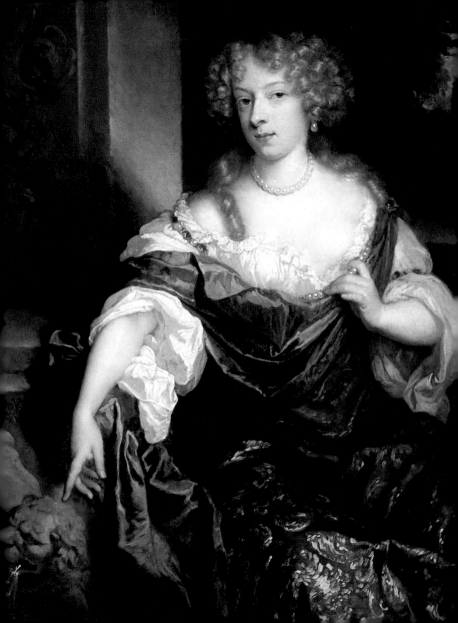

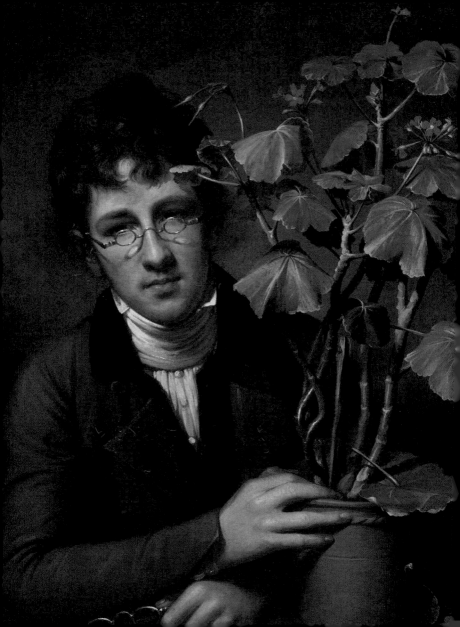

When you buy one houseplant and wonder if you can add 'keen gardener' to your CV.

When your date says they're looking for someone fun.

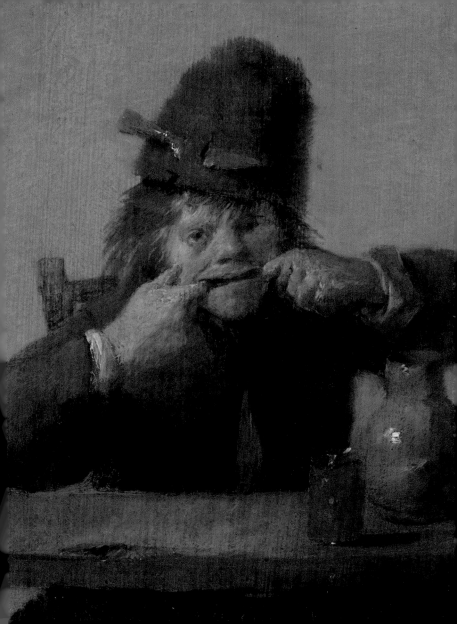

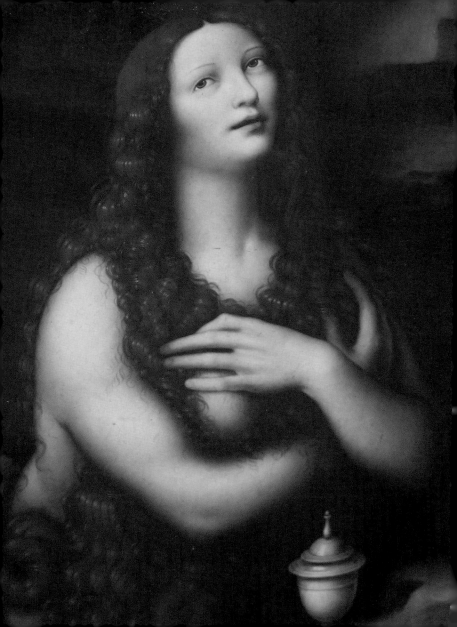

When the doorbell goes just as you're about to get in the shower.

When your mum decides your school uniform is perfectly adequate for another year.

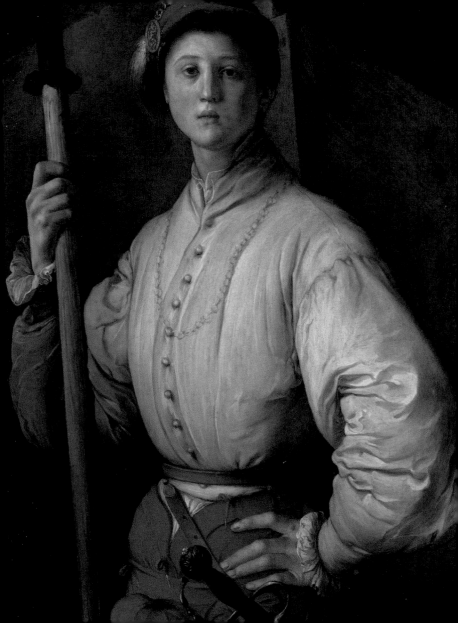

When someone in front of you jumps the queue.

When England score one goal in the first stage of the World Cup and you immediately run to the bookies to put £100 on them winning.

When you come back from holiday and someone says 'was it not sunny?'

*When you get the remote
off your sibling.*

When you're watching a show with your boyfriend and the comedian asks for a volunteer.

When a friend comes
to you for advice.

When the taxi driver drops your boyfriend home after his work do.

When you haven't yet figured out how to navigate social gatherings as an introvert.

Св. Вмч. Варвара

Св. Вмч. Варвари

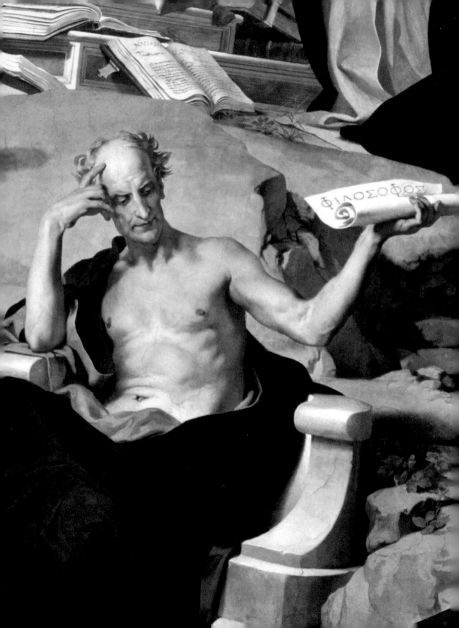

When you hand over another £50 to the gym, knowing you won't go this month either.

When you're too drunk to notice that your friend has been giving you water for the past hour.

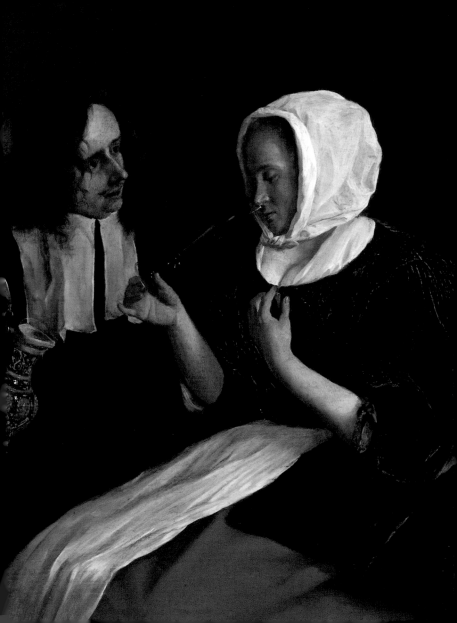

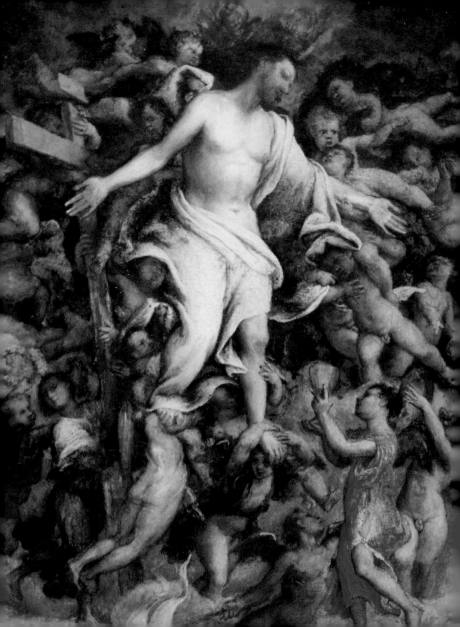

When you're the only person at the party with a lighter.

When you find out where your parents have hidden the Christmas presents.

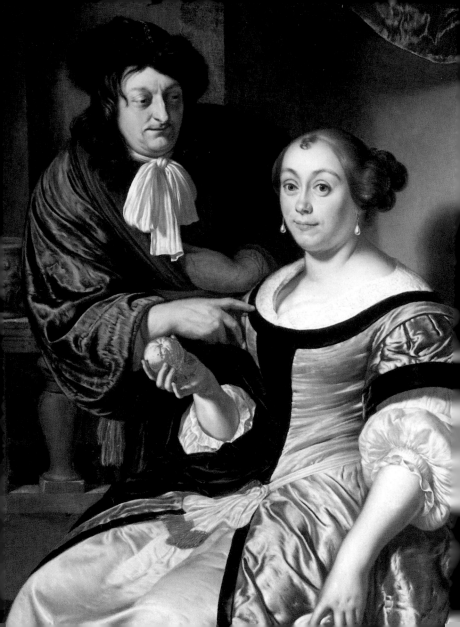

When you're trying to enjoy your lunch in peace and your colleague is telling you about the dream they had last night.

When you do a trust exercise on a work team building course.

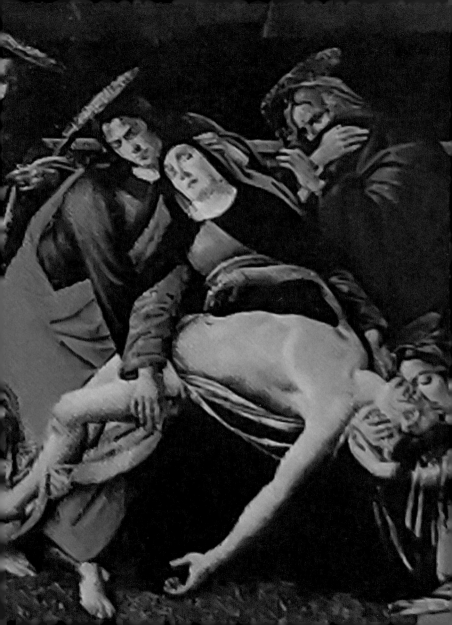

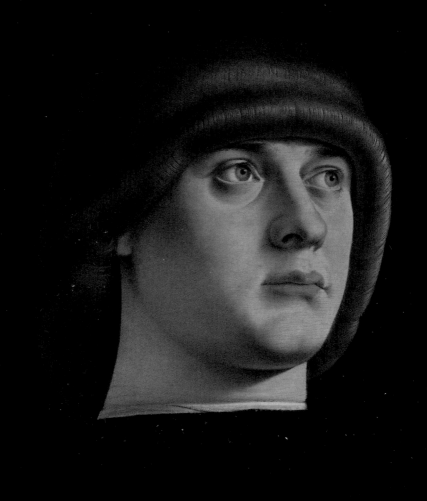

When you take off your bike helmet.

When you move out of your parents' house and discover that pants don't wash themselves.

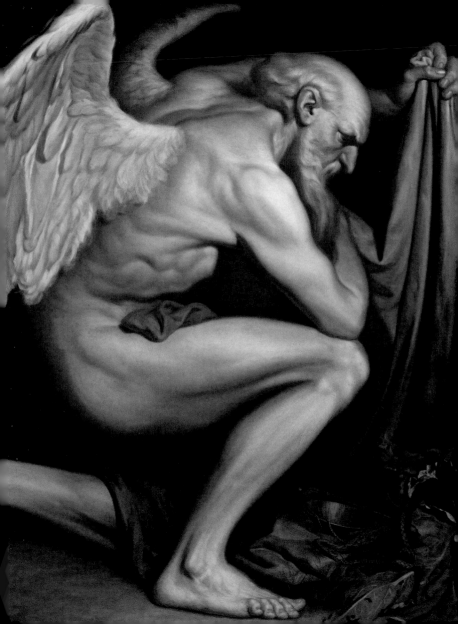

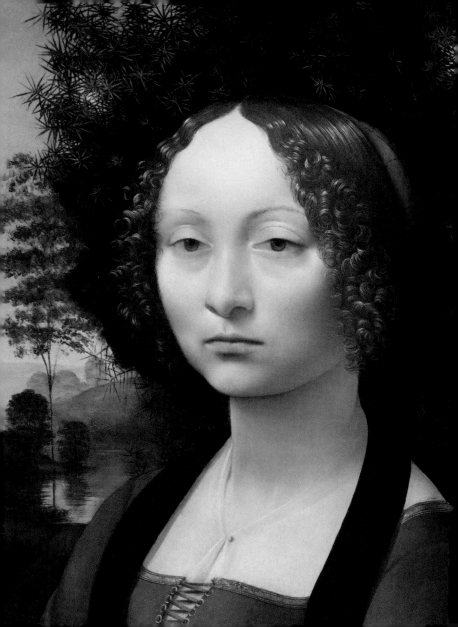

When someone says 'cheer up,
it might never happen!'

When you're bowling and no one has noticed that you've kept the barriers up.

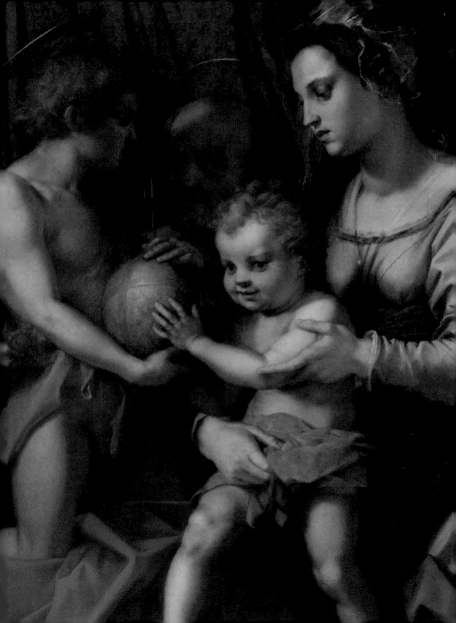

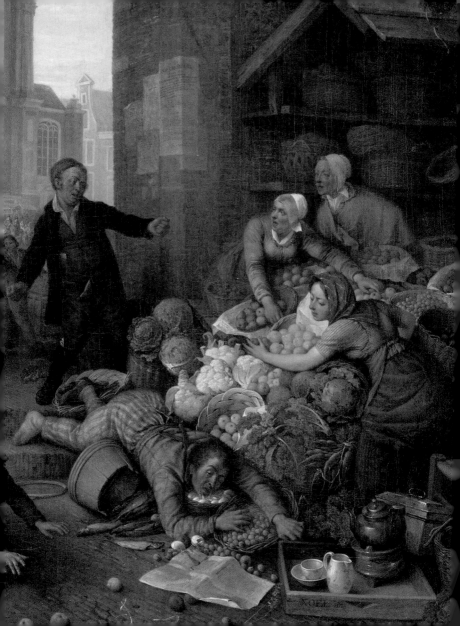

When you haven't quite got the hang of the new plastic-free veg aisle.

When you hit the M25 in rush hour.

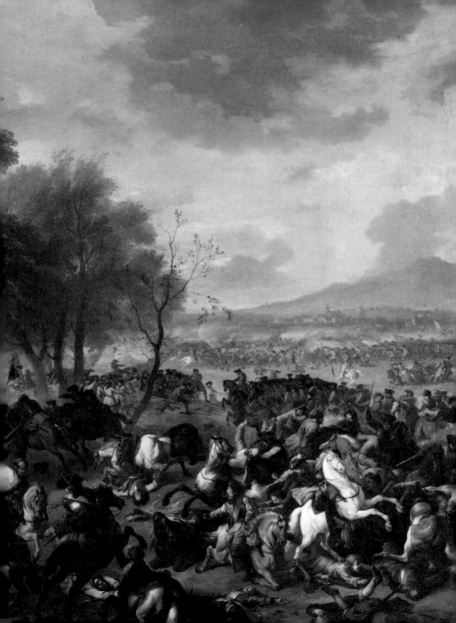

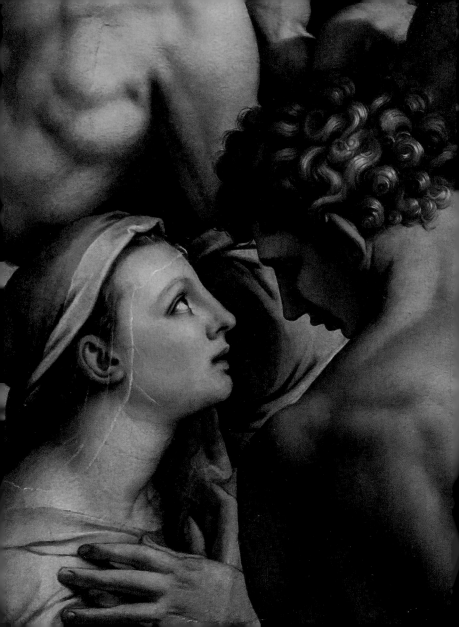

*When he says his mum
is his best friend.*

When your VELUX™ window is a smash hit.

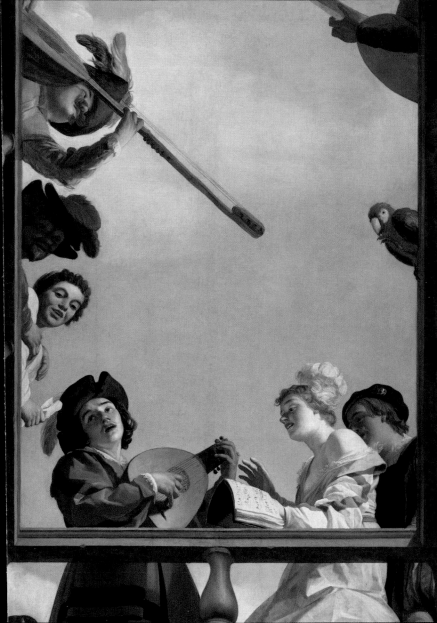

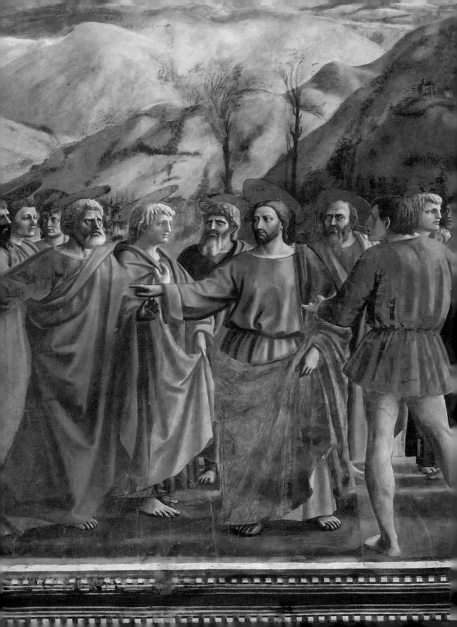

When you try to bargain with the bouncers even though you can't remember your own name and you've lost your trousers.

When he finally texts back but all he's put is, 'haha nice'.

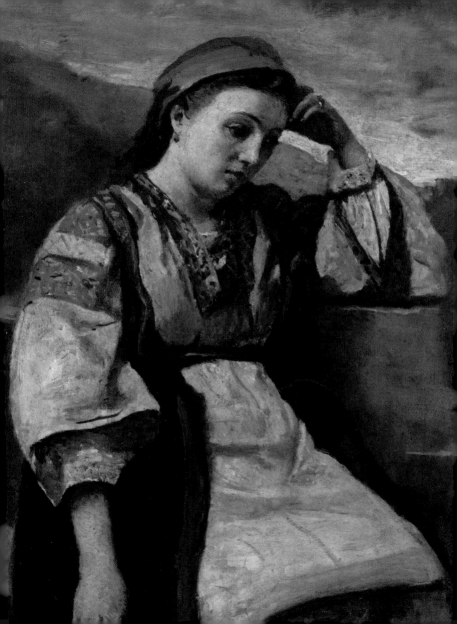

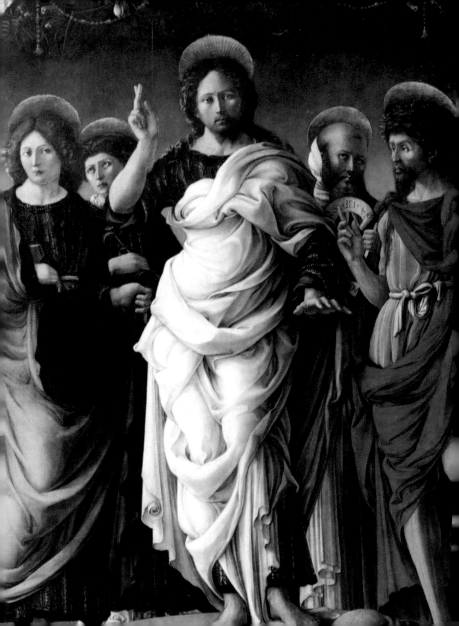

When only the hen is allowed to wear white because she's the hen and it's her hen.

When you don't know what to do with your hands in a photo.

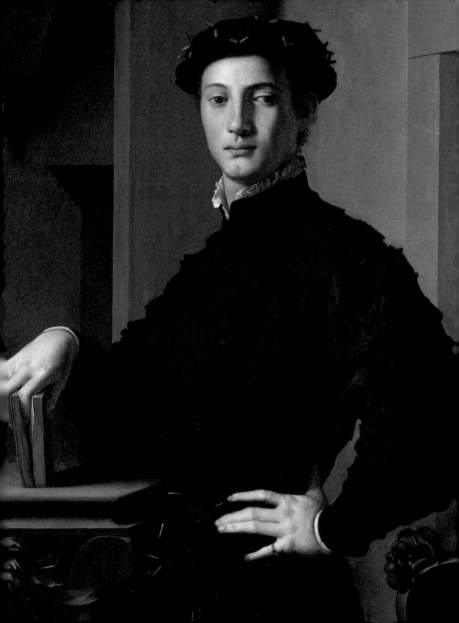

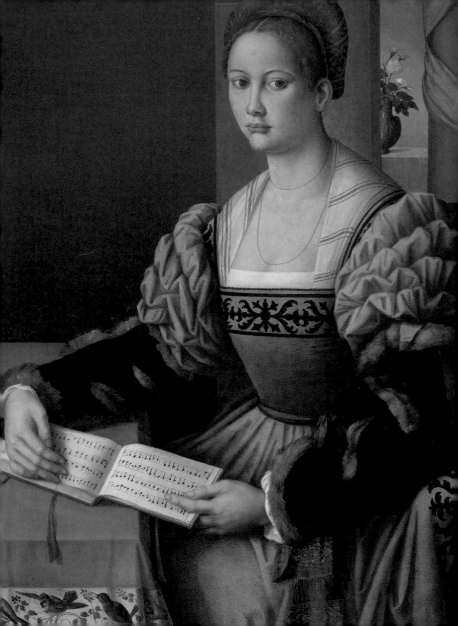

When he says 'I don't get why there isn't an International Men's Day.'

*When you sneak down
on Christmas Eve to give
your presents a shake.*

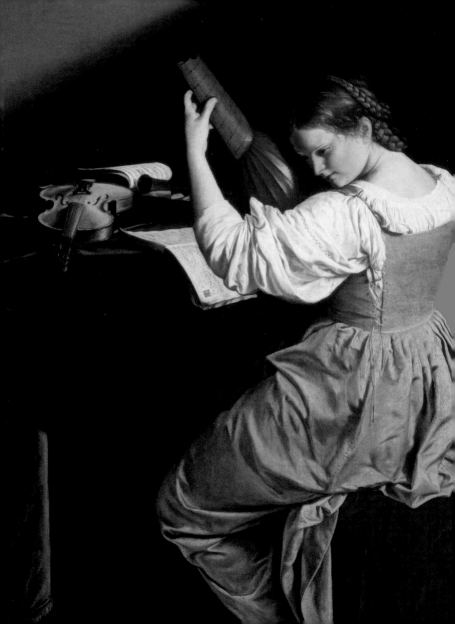

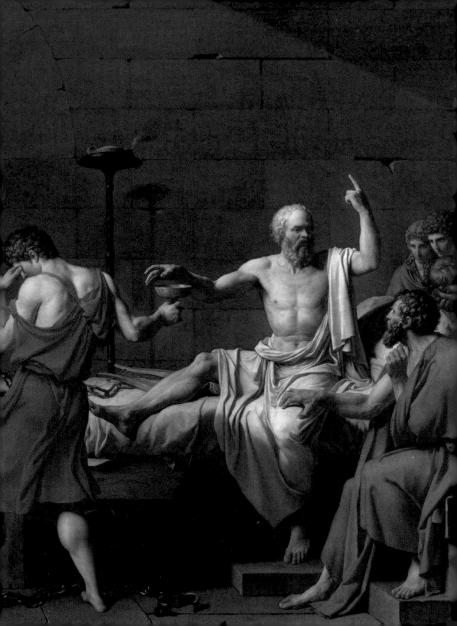

When you finish being sick and are ready for round two.

When you're the only person who's come in fancy dress.

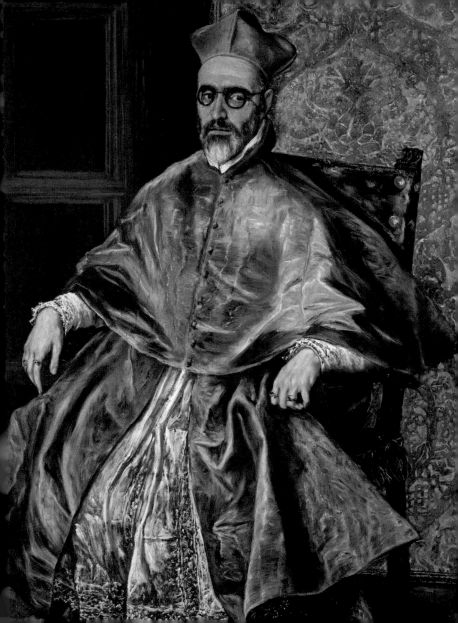

When dancing is not your thing but then the Macarena kicks in.

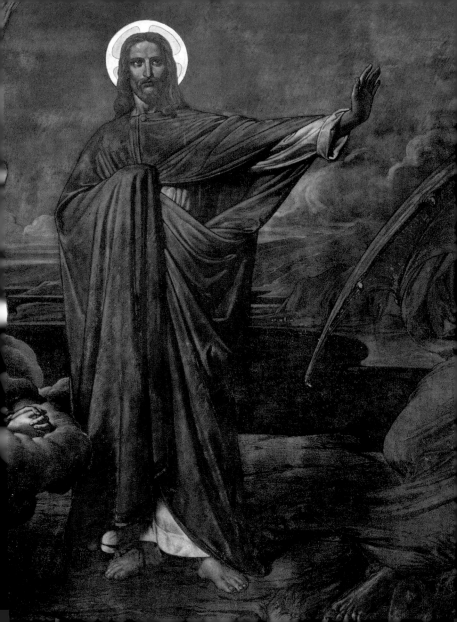

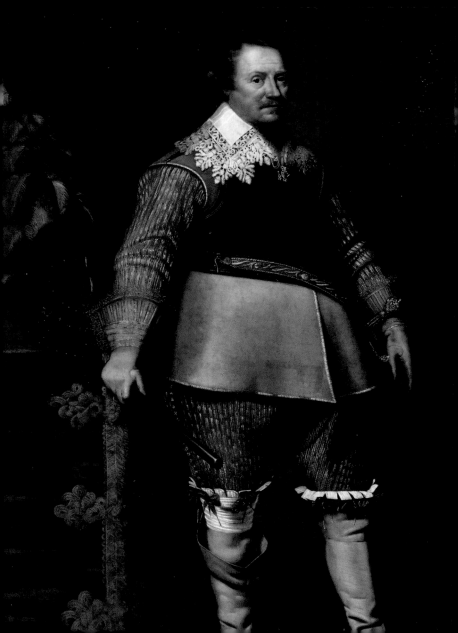

When it's nearly June and your summer body is nowhere to be found.

When you turn vegetarian but you've got all the gear and no idea.

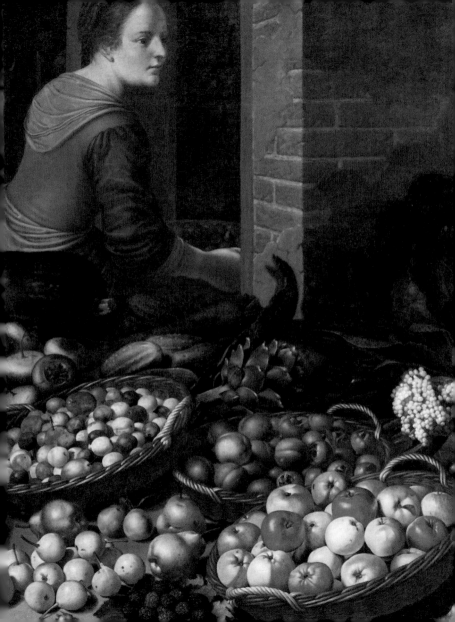

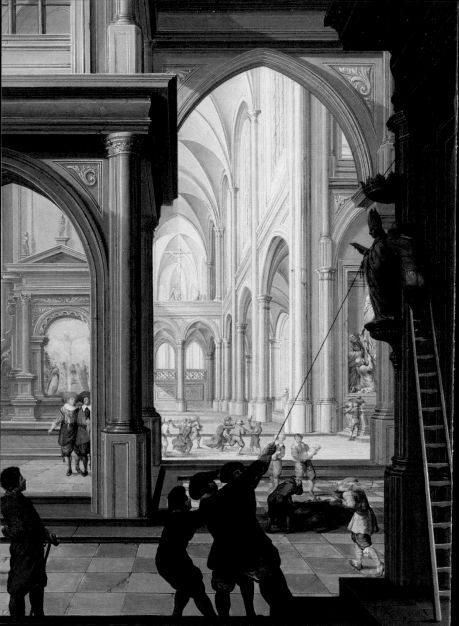

When one minute you're having a civilised pint after work and the next it's 2:00 a.m. and you're climbing the town statue.